CWFOREST

Double*Take*

by Liz Rideal

National Portrait Gallery

Published by Berol Limited, Oldmedow Road, King's Lynn,
Norfolk PE30 4JR, England, 1991

ISBN 0 9515642 5 0

A catalogue record for this book is available from the
British Library

Designed by Jenny Pearson, The Green Button Design Co.,
Norwich
Edited by Luci Collings
Typeset by HW Typesetters, Norwich
Printed by Wayzgoose plc. England

This is number **1106** of a limited edition of 5000

*Front cover: Left: The Rt. Hon. Tony Benn by Dominic Old, 1985
(© Dominic Old); Right: The Rt. Hon. Tony Benn by Mark Boxer,
1970s (© the Estate of Mark Boxer)*

Contents

Acknowledgements

I am grateful to the artists and photographers represented here without whom this booklet would not exist. I would also like to thank Karen Robinson of Berol whose enthusiasm carried the project through, Richard Pavitt of TCI, and Luci Collings for her meticulous editing. At the Gallery I would like to thank my colleagues Suzanne Benney, John Cooper, Sally Crowden, Penny Dearsley, Gillian Forrester, Louisa Hearnden, Ian Thomas, Debbie Williams and particularly Terence Pepper who made many useful suggestions regarding the selection of the photographs.

Liz Rideal
National Portrait Gallery

Photographic acknowledgements

The National Portrait Gallery would like to thank the following for kindly giving permission to reproduce copyright photographs on the following pages:

7 © Eileen Agar; 33 © Peggy Angus; 11 © Avigdor Arikha; 38 © Cecil Beaton photograph courtesy of Sotheby's London; 13, 17 © the Estate of Mark Boxer; 32 © Bob Collins; 35 © Victoria Crowe; 6 © Lucinda Douglas-Menzies; 19 © Allen Jones; 10 © John Minihan; 12 © Dominic Old; 18 © Terry O'Neill; 39 © Bryan Organ; 34 © Juliette van Otteren; 24 © Miriam Reik; 25 © Gerald Scarfe; 43 © Hans Schwartz; 42 © Liam Woon

All other photographs are copyright of the National Portrait Gallery. Special photography was undertaken by Barnes & Webster.

Karisma

Introduction

'Double Take' was originally an exhibition mounted by the Education Department of the National Portrait Gallery and sought to compare portraits made by painted, graphic and photographic means. In a sense it compared the handmade with the machinemade, and considered the creative range of these different media in terms of technical similarity, style, mood and what can best be described as the 'magic' of the individual artist's or photographer's work. This book is a record of the exhibition and continues the theme, incorporating a larger selection of works and broadening the scope of media and techniques.

What makes a good portrait? Has photography something to offer that cannot be achieved through pencil or paint, or vice versa? Both the graphic and the photographic process bear witness to a creative event: the transmutation of physical and emotional characteristics into two-dimensional form. Yet if the portrait is to be successful in artistic terms by either route it must somehow convince us that the sitter lives in the work or that it captures an aspect of that person's character.

Photography is a precise record. However, the quality of a photographic portrait and its ability to tell us something about the personality of the subject are influenced by many of the same elements that absorb the artist: composition, use of light, colour and texture and the way the photographer perceives his subject. These can be expressed not just in the taking of the picture itself but in the subsequent manipulation of the tonal qualities during the processing of the print.

It is perhaps in the graphic art of drawing that the greatest freedom of expression lies. The artist has total control and a varied choice of techniques and media ranging from the earliest materials used by man, such as charcoal and chalk, to more recent inventions like the modern lead pencil and coloured crayons.

The lead pencil (actually graphite) is a comparatively new medium, and was not in common use as a drawing instrument until the mid-eighteenth century. During the seventeenth century a flourishing manufacture of wooden pencils arose in England. However, it was not until the 1790s that leads of predetermined hardness or softness were produced by a French chemist who undertook to solve the problem of making pencils when France was cut off from the English supply of graphite (a problem mentioned in despatches from Napoleon during the 1790s). Colour pencils, like photography, are an even newer medium and the great advances of recent years in their range and quality offers the artist great expressive potential. The portraits in this book of Roger Daltrey and Denis Healey are but two examples of the medium's broad scope and continuing appeal. One of the best-known contemporary exponents of this medium, who has done much to enhance and promote its status, is David Hockney.

It is to stimulate interest and debate in the use of pencil and in the creative range of portraiture in general that Berol, under the auspices of the Karisma Fine Arts Division, has kindly funded the publication of this book.

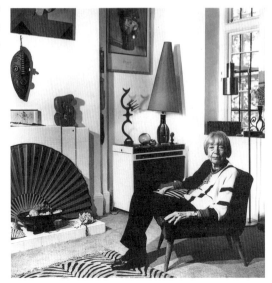

Bromide print, 1987
By Lucinda Douglas-Menzies
(NPG X29869)

Eileen Agar
(born 1899)
Surrealist artist

Lucinda Douglas-Menzies's photograph of the Surrealist painter Eileen Agar, taken in the artist's home, gives us an immediate impression of her subject's own aesthetics. Repeated forms in the room and in its furnishings combine with one another to enhance the feeling we have about the sitter: for example, the wrought-iron candlestick holder and the sculpture beside the lamp, and the patterning on her jumper, which echoes that of the rug, and which is picked up by the shells and fan in the fireplace. Agar is seated on a low chair, her body elegantly concave and with her long hands and fingers stretched out upon the armrest. Her face is turned towards the camera, but there is no expression save an almost blank, mask-like stare that reflects that of the mask hanging above the mantlepiece. Confident and relaxed, she has become a living object integral to her surroundings.

In the artist's self-portrait (painted sixty years previously on to a coarse canvas), Agar has all the confidence of youth, with the same qualities of poise and self-assuredness that we see in the photograph. She portrays herself in three-quarter profile, looking towards us; a large red drape forms the backdrop, which complements her green and blue dress. The green is picked up again in the colouring of the facial shadow, which contrasts with the orange and pale yellow impasto of the other skin tones. Her auburn hair is thick and bobbed. As a student in Paris in the late 1920s, Agar would have been influenced by the Surrealist avant-garde, and the heavy black delineation of features seen here is typical of the period.

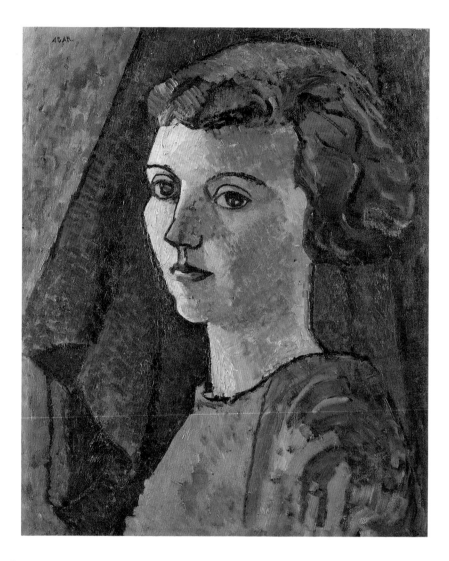

Oil on canvas, 1927
Self-portrait
(NPG 5881)

Bromide print
21 December 1920
By George Charles Beresford
(NPG X125)

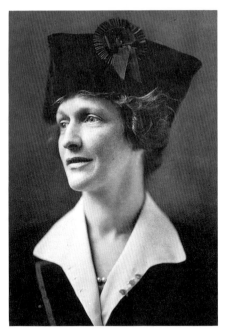

Nancy Witcher Langhorne, Viscountess Astor
(1879 – 1964)
Politician and first woman MP

In 1919 the American-born Lady Astor made history by becoming the first woman to be elected as a Member of Parliament; throughout her political career she campaigned tirelessly for women's rights and temperance. Beresford's sensitive portrait study, made the following year, was used by Lady Astor as her official publicity photograph, and as such is an interesting work because her approval implies acceptance of this as her public image. As Britain's first serving woman MP she would have expected to encounter prejudice and the inevitable scrutiny of her looks, demeanour and clothing; perhaps mindful of this, therefore, the photograph presents us with a soberly dressed, demure, yet confident woman. The elegant white silk collar emphasizes the pool of light that illuminates her face and in turn draws attention to the fine line of her nose. Her gaze is averted, her look not proud but purposeful – reserved and feminine yet with no hint of sexuality.

In 1923, three years after the photograph was taken, Lady Astor sat for one of the greatest Edwardian portraitists, John Singer Sargent. This drawing is in a sense a 'standard' work, for Sargent often employed this format, using the charcoal broadly to map out the sitter's features. He appears particularly interested in Lady Astor's hat, veil and pearls – peripheral visual attributes which enhance the status of the sitter and reinforce her look of quiet confidence. It is, however, the face on which Sargent concentrates: the direct gaze, clearly delineated nose and firm mouth. Lady Astor's face is framed beneath a crescent-shaped hat, whose diagonal shading corresponds to the angle at which it is worn, and which forms a dark, semi-circular surround that also serves to draw our attention to her piercing eyes. The highlights in the drawing have been created by Sargent rubbing away areas of charcoal with an eraser.

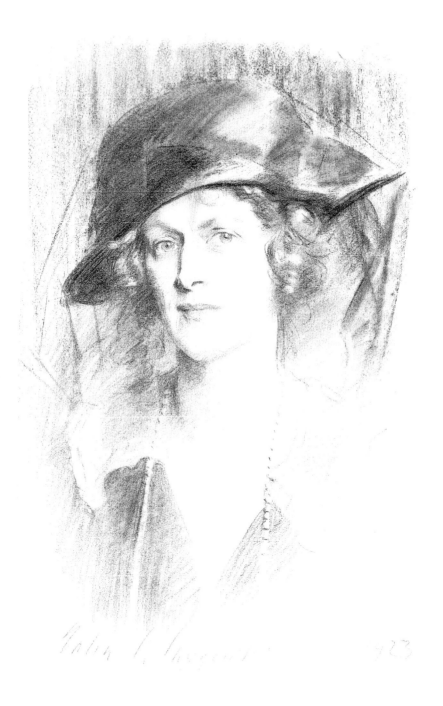

Charcoal, 1923
By John Singer Sargent
(NPG 4885)

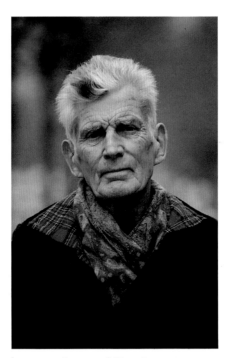

Samuel Beckett
(1906 – 1989)
Dramatist and novelist

Avigdor Arikha's drawing - in pencil on brown laid paper over painted with gouache - was made when Beckett was sixty–five. The writer's heavily wrinkled face bears the familiar, care-worn look that we associate with the physical manifestation of his deeply pessimistic view of the human condition. Arikha's pencil worries its way across the forehead of his subject in such a manner that glasses and wrinkles merge in a flurry of lines. Beckett's tufty hair is briskly drawn, the lines bunched together to make pictorial sense of this straight, wiry brush. Below, his ear is beautifully delineated - careful, thoughtful and by far the sharpest part of the portrait. The rest of the features are, by comparison, only hinted at: the some-what beaked nose and the closed, pensive mouth - the whole expression intensified by the downward stare. The twitching mass of lines depicting his neck flow over into the lines that describe his rollneck jumper, its sleeves

rucked up to reveal bare, skinny arms. We know only by the slightest of marks that Beckett's hands lie together in his lap between his crossed legs. A few sketchy lines at the lower half of the drawing give us the necessary infor-mation to complete the picture of this famous twentieth-century intellectual, whose twitchy, private character is captured in the febrile quality of Arikha's jerky and scribbled line.

The fourteen-year gap between drawing and photograph is plainly apparent, as in Minihan's work an older, mellower Beckett now stares us straight in the eye. His clothing, however, is youthful, and a bright tartan scarf picks up the twinkle in his inquisitive, steel-blue eyes. There is a sparkle, too, in the colour photograph, which contrasts with the sagacity of the sitter. Minihan, an *Evening Standard* staff photographer, took many photographs of Beckett (who dis-

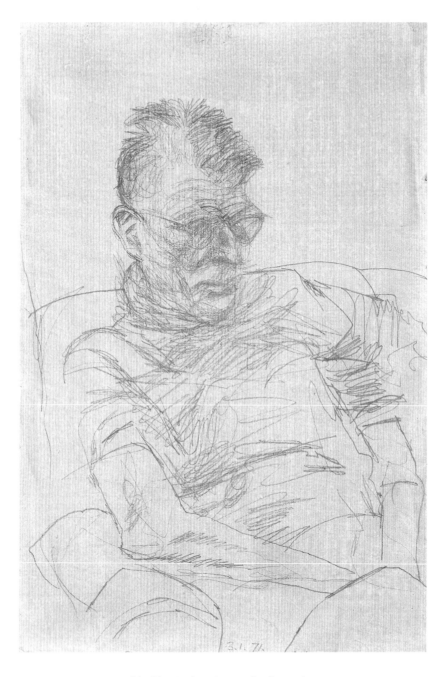

liked having his picture taken), a project
that continued until the writer's death
in 1989.

Pencil on laid paper, 1971
By Avigdor Arikha
(NPG 5100)

Bromide print, 1985
By Dominic Old
(NPG X25271)

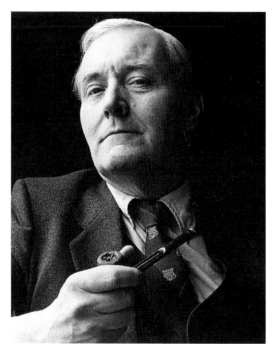

The Rt. Hon. Tony Benn
(born 1925)
Politician

Frequently lampooned by the media for what have occasionally been seen as eccentric left-wing views, Tony Benn has long been a favourite subject for cartoonists. In this ink and crayon drawing, Marc has given Benn a pop-eyed look to suggest a gentle hint of madness. The three squiggles which make up his hair, the deeply furrowed brow and his intensely set mouth together amount to a simple, yet animated portrait. Benn's red (Labour) kipper tie and stiff arms, as well as emphasizing his wiry physique, reinforce the verticality of the composition. His hands, placed as if supporting the weight of his entire body, convey the 'no-nonsense' approach of a politician.

Dominic Old's photograph is a far more respectful and straightforward portrait of this sixty-year-old outsider of British politics. The viewer instantly acknowledges that here is a profoundly serious politician, for whom our interests are of paramount concern. This aura of sagacity and caring is enhanced by the strong, unforgiving lighting, the sense – suggested by the angle of the body and the tilt of the head – that Benn is reclining in a chair, and the fact that he is smoking his pipe, an accoutrement he is rarely seen without.

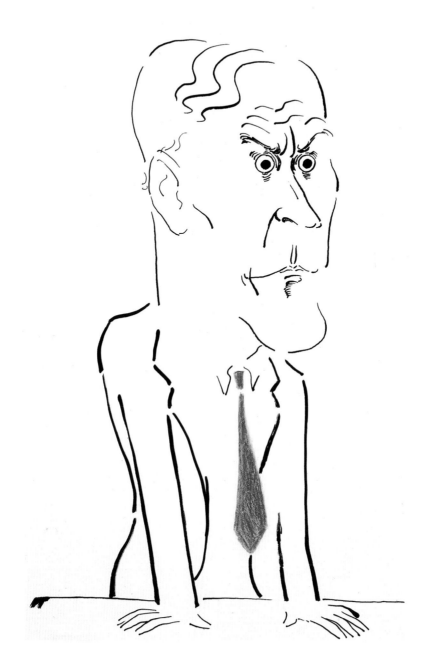

Ink and coloured crayon, 1970s
By Mark Boxer
(NPG 5920[4])

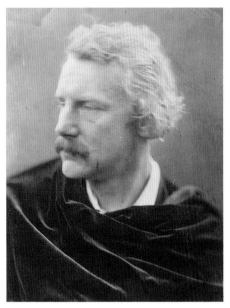

Sir Coutts Lindsay, 2nd Bt.

(1824 – 1913)

Artist; owner of the Grosvenor Gallery and Trustee of the National Portrait Gallery

It is strange how much more 'painterly' the photograph of Sir Coutts Lindsay appears when compared with the water-colour. Julia Margaret Cameron was a photographer who specialized in the close up, slightly soft focus head-and-shoulders portrait. Here, in order to create a feeling of timelessness, she has swathed her subject in rich velvet, the texture becoming more evident as the light rakes across the front folds, pulling our eyes back into the depths of the image. Underneath this lush cloak shines a white collar, revealing beneath it a more delicate and youthful neck than the stiff, peach-coloured trunk suggested in the watercolour. Lindsay's light tousled hair, with its unruly curls, sweeps back to reveal a wide and deeply furrowed brow. He has the same distant, abstracted gaze as in the watercolour, and below the dignified, quasi-military moustache his chin is rigidly set.

By contrast, Jopling's watercolour presents us with an intimate record of a dapper man about town: shiny shoes, cigar, signet ring, monocle, hat, handkerchief and jolly tie make a telling list, while Lindsay carries his walking stick slung under his arm like a gun. He stands at the entrance to his gallery – the words 'Grosvenor Gallery exhibition now open' are clearly discernible on the placard beside him – whose exhibition policy was satirized by Gilbert and Sullivan in their operetta *Patience*:

> *A pallid and thin young man,*
> *A haggard and lank young man*
> *A greenery yallery Grosvenor Gallery*
> *Foot-in-the-grave young man.*

Although Lindsay himself is not so very young here, he does indeed appear peculiarly lifeless, like a character from an illustrated colour magazine. There is a certain resolve in his stare, though, and a conscious elaboration in his graceful,

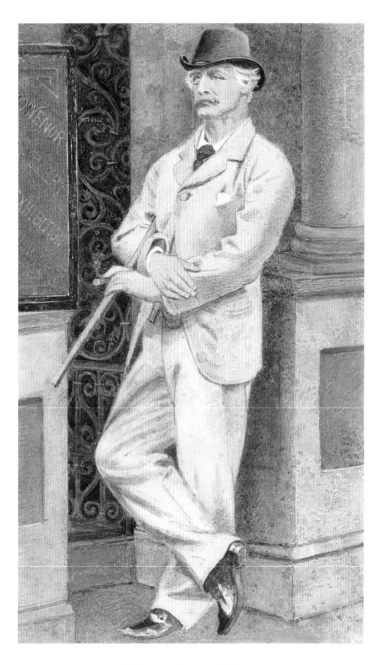

nonchalant pose, but overall the picture
seems slight in its characterization
beside the sensitivity of Cameron's
portrait.

Watercolour, 1883
By Joseph Middleton Jopling
(NPG 2729)

Bromide print, 1930
By Dorothy Wilding
(NPG X30469)

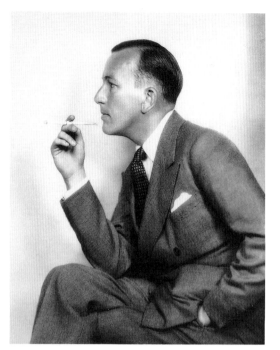

Sir Noël Coward
(1899 – 1973)
Playwright and actor

This delightful sketch gently satirizes the studied elegance that so typified Coward, while itself being the epitome of elegant caricature. It is drawn in black ink in lines of varying thickness, with areas of solid black to suggest the hair, bow tie and piano keys. The pivotal point of the composition is the feathered pink carnation in Coward's lapel. The head, proportionally larger than the body, portrays Coward with an elongated hook nose and a tiny, frogspawn-like eye that fixes a view out of the profile. A slight stoop is suggested in the angle of the shoulder, and this curve is echoed by Coward's hands, whose dripping fingers are just about to touch the keys. A further amusing note is introduced with the framed portrait of the sporty, moustachioed gentleman that sits on the piano.

Less often means more, a point proved in this simple little portrait – commissioned for the cover of a volume of Coward's lyrics (Methuen, 1983) – which has brilliantly captured Coward's spirit with the sparest of means.

Dorothy Wilding, in her photograph of the young Coward, also draws attention to his profile, but rather than caricaturing it, she uses the profile in the composition of the work. Almost as if adopting Hogarth's principal of the serpentine 'line of beauty and grace', Wilding creates a Rococo swirl made up of Coward's head and body. This sweeping line is tempered by Coward's crisp elegance – his dapper suit, perfectly knotted tie and neatly folded white handkerchief. As in Boxer's caricature the hands are prominent, here shown clasping the *de rigueur* cigarette holder. Coward's air of studied nonchalance was a characteristic pose, and Wilding's photographic style has perfectly captured the essence of this most English of cabaret entertainers.

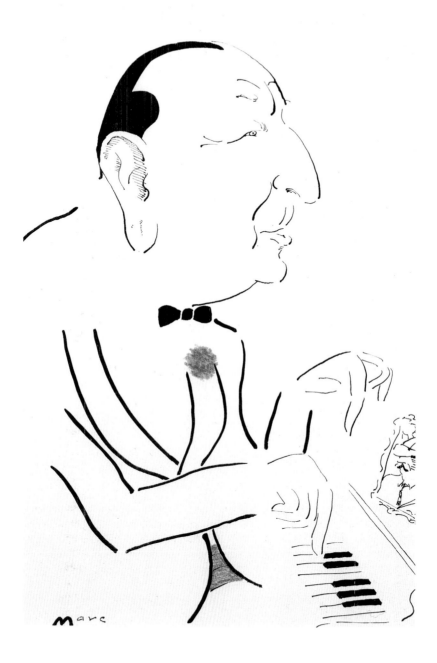

Ink and coloured crayon, 1983
By Mark Boxer
(NPG 5920[7])

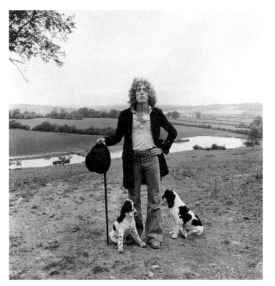

Bromide print, 1978
By Terry O'Neill
(NPG X35950)

Roger Daltrey

(born 1944)

Vocalist for The Who, film actor and landowner

Roger Daltrey first came to fame in the 1960s as the lead singer of the pop group The Who. This portrait was commissioned for the sleeve of their album *Face Dances;* released in March 1981, the record reached number two in the UK album charts. The drawing – half face, half skull – is a disturbing work, reminding us of our mortality and of the fact that we are all but flesh and blood. It is meticulously rendered, with the deep yellow of the background forming a rich gold patina that alludes to the head of blond curls sported by the singer in his youth. At forty-four (when this portrait was made), the hair is cropped and brushed elegantly back off his face. The softness of the crayon, which is hand-smudged, provides an excellent foil for the sharp pencil line, reworked on top. The detail is sparse yet precise, and the skull cracks quiver as Daltrey is caught in a frozen, timeless smile, staring one-eyed and square-jawed from out of his eight-inch-square cardboard frame. This por-

trait is one of four of Daltrey illustrated on the record sleeve, the others being by Mike Andrews, David Hockney and David Inshaw.

O'Neill's somewhat tongue-in-cheek portrait shows the rock star at home on his country estate in Sussex. Flanked by two black-and-white spaniels, Daltrey poses as a country gentleman, complete with hat and walking stick. His open-neck shirt reveals a large silver cross, and the long black jacket evokes a dandyish air which is at odds with the flared jeans that date the portrait to the late 1970s. The chiselled, angular nature of Daltrey's facial bone structure is as evident here as in the drawing, and the mass of golden curls falling on to his shoulders underlines the hippy period feel. Renowned for capturing the unexpected, O'Neill has produced a slightly surreal portrait which is at once witty and elegant. Although quoted as

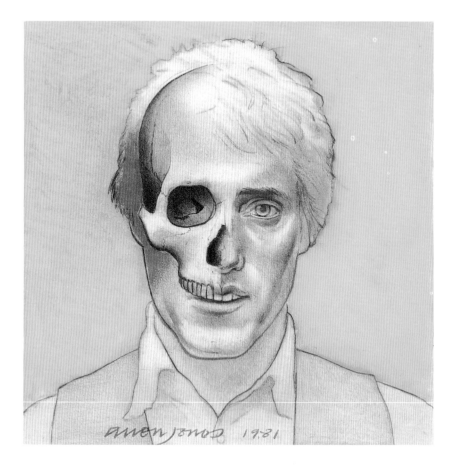

saying that 'it is the subject that makes
the photograph, not the photographer',
this image bears witness to a working
complicity between photographer
and musician.

Crayon and pencil, 1981
By Allen Jones
(NPG 5912)

Albumen print, 1861
By John and Charles Watkins
(NPG X14339)

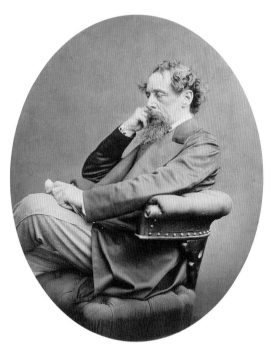

Charles John Huffam Dickens
(1812 – 1870)
Novelist

Ary Scheffer's portrait was painted shortly after the publication of *Hard Times* (1854) while Dickens was working on *Little Dorrit* (1855–1857). It gives us a romantic view of the novelist who, with his hands elegantly clasped before him displaying a small ring on his little finger, gazes into the distance, presumably for inspiration. Like the portrait of Ellen Terry, the artist has used the device of chiaroscuro, highlighting the head, the stiff white evening shirt and the elongated hands. Scheffer has flattered Dickens by smoothing away the lines and imbuing him with a touch of abstracted genius through his serious, sympathetic stare.

John and Charles Watkins's photograph – framed in an oval mount to resemble a painted portrait – presents us with a formal view of this most distinguished Victorian writer. Seated in a robust studio chair, Dickens adopts the traditional thinker's pose; with his elbow resting on the arm of the chair and his hand supporting his head, he looks down and away from the camera. His head is so sharply in focus that we can easily discern the wiry, straggly beard, the texture of his skin and his long eyelashes. The Watkins's claimed that their photographs were 'as remarkable for their agreeable fidelity to nature as for their brilliancy of production and their economy of cost', and they have here succeeded admirably in capturing the aura of this great man.

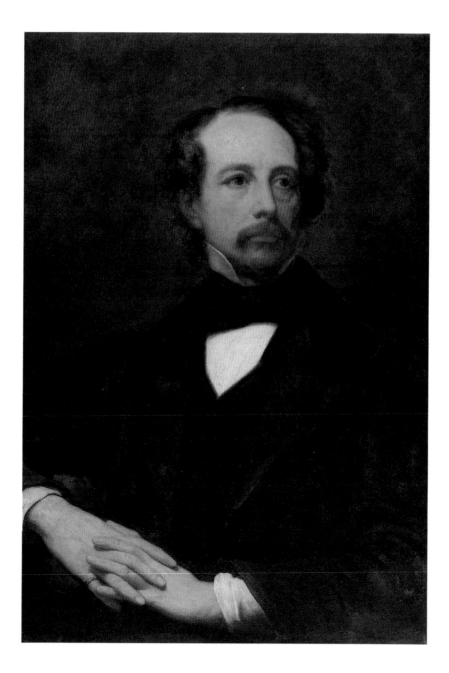

Oil on canvas, 1855
By Ary Scheffer
(NPG 315)

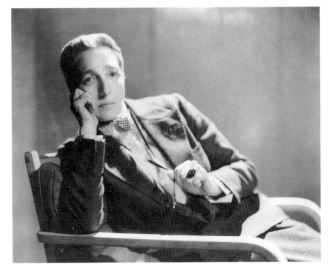

*Modern bromide print
from an original 5″ × 4″
nitrate negative, 1932
By Howard Coster
(NPG X10422)*

(Marguerite) Radclyffe Hall
(1880 – 1943)
Novelist and poet

Radclyffe Hall is today best known for her controversial book *The Well of Loneliness* (1928), in which a lesbian relationship was openly discussed in print for the first time (publication resulted in a trial at which the novel was declared obscene). These two portraits, made fourteen years apart, record Hall's predilection for dressing in male attire. Buchel's 1918 work belongs to a particular style of fashionable portrait painting, here using a blue background to soften and 'prettify' the subject. Hall, half smiling, her hair tied back, looks out of the canvas through soft and delicately painted eyes. The black ribbon of the looking glass weaves its way between the fingers of her left hand and vies for our attention as our eyes flit from the hand to her face via the glistening pin in her cravat.

In 1932 Hall sat for the self-styled 'Photographer of Men', Howard Coster, who would only photograph male subjects and 'women of character and achievement', thereby expressly excluding from his lens the lucrative society portraiture which relied for its success on retouching and flattery. In Coster's portrait Hall reclines in a chair and looks us straight in the eye; she appears neat, confident, clipped and calm, and betrays the merest suggestion of a smile. The slant of her body – reinforced by the diagonal composition and strong lighting – is balanced by the strong vertical thrust of her upright, shadowy arm. Despite the fourteen-year gap between the two portraits, both artists capture Hall's characteristic way of holding her monocle ribbon, which in both pictures provides a focal point and a compositional tension.

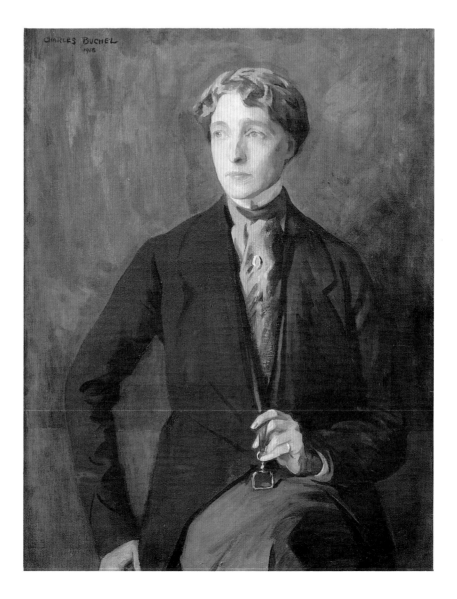

Oil on canvas, 1918
By Charles Buchel
(NPG 4347)

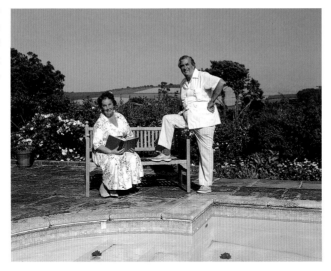

The Rt. Hon.
Denis Winston Healey

(born 1917)

Politician

Britain has a fine tradition of caricature dating back to Hogarth in the early eighteenth century and passed on through artists such as Gillray, Rowlandson and Cruickshank, who developed the distinctive genre of political caricature as we know it today. Scarfe's penetrating satirical portrait of Denis Healey, like the work of these earlier cartoonists, exaggerates the salient physical features of his subject: Healey's round face, high colouring, double chin, bushy eyebrows, rabbit-like pointed teeth and wavy black hair – (this last delineated in heavily worked black crayon). The success of the work as a political satire derives from a number of elements, but principally from the way in which Healey is depicted as a puppet, an image intensified by the bold use of colour that makes the figure resemble a brightly painted fairground toy. The colour scheme is given further emphasis by vigorous crosshatching and clever overlay. Finally, the artist's signature appears graffiti-like on the white body colour that partly obscures previous workings.

Reik took his double portrait (a magazine commission) of Healey and his wife Edna on a blazing hot day at the Healeys' home in Sussex. It is a vibrantly colourful image, which betrays a slightly satirical interpretation of the home life of this well-known Labour politician. The relaxed, homely atmosphere is enhanced by the comfortable summer clothes and the poolside location, and the red roses floating on the surface of the water complement the couple in addition to alluding to the emblem of the Labour Party. In the distance the rolling Sussex Downs provide a backdrop to this shimmering presentation of happy domesticity. Blue sky and blue pool frame the pair, who are the focus of our – and their – attention, far removed from the rigours of urban political public life.

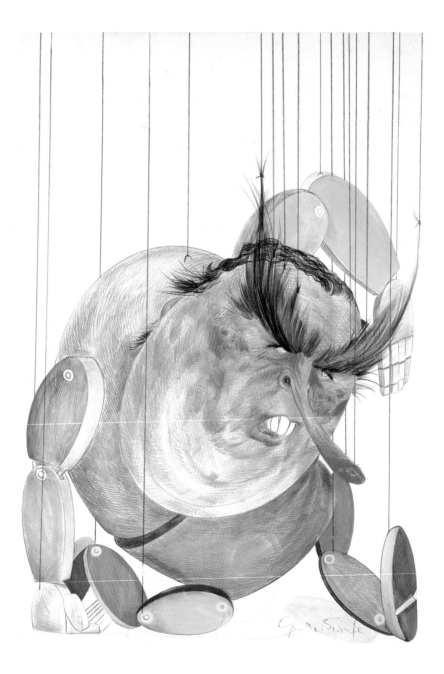

Watercolour with body colour and crayon, 1976
By Gerald Scarfe
(NPG 6019)

Bromide print, 12 April 1912
By George Charles Beresford
(NPG X12903)

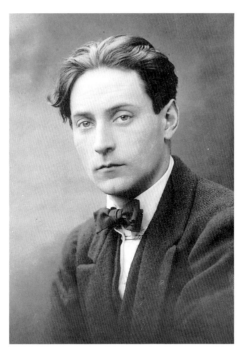

Sir Compton Mackenzie
(1883 – 1972)
Writer and novelist

George Charles Beresford, who took this photograph of Sir Compton Mackenzie in 1912, is perhaps better known as the model for M'Turk in Rudyard Kipling's stories of *Stalky & Co.* (1899) than as a photographer. Between 1902 and 1932 he ran a successful portrait studio in London, where he photographed writers, artists and politicians. This portrait of the writer now principally remembered for his delightful comic novel *Whiskey Galore* (1947; later made into a film on the Scottish island of Barra), is a quietly understated portrayal of a charismatic and intensely creative man. Mackenzie was a romantic and attractive figure who persisted in leading a bohemian life style despite receiving such honours as the OBE (1919) and the life presidency of the Siamese Cat Club. Both photograph and drawing make a feature of Mackenzie's dapper style of dress, his heavy-lidded eyes and his hair, combed back to expose the expansive brow of an intellectual.

Powys Evans's seemingly straight-forward drawing is, on closer inspection, a complex and contradictory image. Balanced, elegant, rhythmic and poised, the work has nonetheless a considerable tension, created in part by the use of texture and pattern. There is an initial feeling of roundness, which is enhanced by the curves of the chair on which Mackenzie sits and echoed in the curves of the beautifully observed brogues and the scrolls on the armrests. Although apparently calm and relaxed, the tension of the sitter is indicated in the faintly noted frown, slightly pursed lips and the careful portrayal of the hands, each specifically held in an awkward position. This feeling of unease is reinforced by the placing of the figure within a tight, rectangular border. The straight lines of Mackenzie's legs compete for space with the elegant curves of those belonging to the chair, and the figure is thrust forward by the device of the cropped foot and the absence of the chair's back legs.

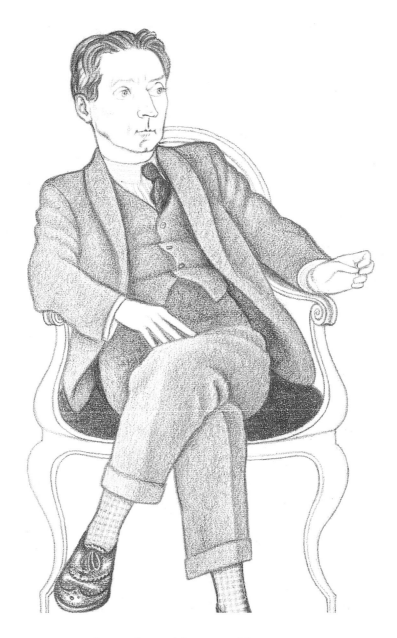

The artist has used the texture of the paper as the basis for his various patterns, working the crayon into the surface to make the deep tones that give body and substance to this concise work with its slight hint of caricature.

Crayon, undated
By Powys Evans
(NPG 5872)

Albumen carte-de-visite print,
c. 1857
By Goodman of Derby
(NPG X29670)

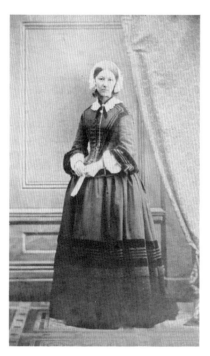

Florence Nightingale
(1820 – 1910)
Pioneer of modern nursing

Such was the public demand for pictures of this heroine that this carte-de-visite was one of the most popular images of the 1860s. It is a typical studio work by a provincial photographer, and features the same background that Goodman used for all his clients – a *trompe l'oeil* painting of wall panelling. The linear severity of this panelling is tempered by the tied-back curtain on the right-hand side of the picture. Unfortunately, the camera captured Nightingale appearing to sneer, leading her to refer to this photograph as 'Medea after killing her children', and perhaps explaining her disinclination to be photographed on other occasions. Certainly, few photographs of her were ever taken. This image was later used as the basis for the design on the £10 banknote.

The pencil drawing by Sir George Scharf, the first director of the National Portrait Gallery, is of a detail of the photograph, made the same year. Here, the character of the sitter has undergone a subtle change along with the change of medium. The softly drawn lines, fading away at the edges, give a relaxed aura to the sitter. Her tiny mouth now evinces determination, and her appropriately Victorian deportment naturally raises her chin and lifts her gaze – no longer a glare, but a perceptive, caring look.

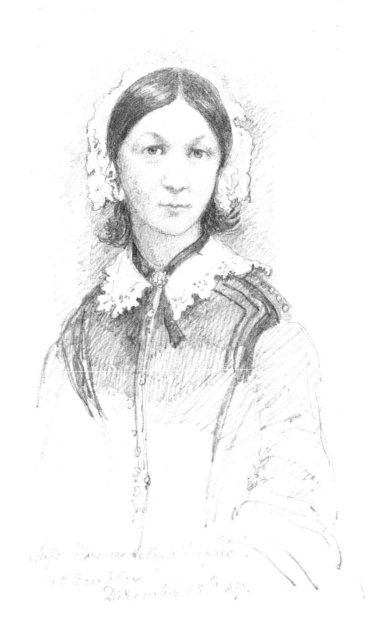

Pencil, 1857
By Sir George Scharf
(NPG 1784)

Bromide print, c. 1927
By an unknown photographer
(NPG X1685)

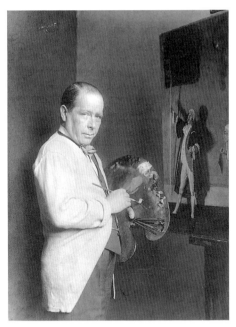

Sir William Newenham Montague Orpen
(1878 – 1931)
Painter

This photograph, taken by an unknown photographer, records Orpen painting *The Black Cap*, an anti-death-penalty work that mocked the judicial process (it was exhibited at the Royal Academy in 1928). Orpen's expression is one of patient boredom. Smartly attired, he wears beneath his white painter's overall a bow tie and buttoned waistcoat. Holding his palette in his left hand, he simultaneously grasps four brushes; a fifth, in his plump right hand, is pressed against the palette, resting his arm rather than mixing paint. Though very much a traditional view of an artist at work, this consciously posed photograph has more the feel of a publicity shot than that of an incisive portrait.

Orpen's self-portrait, which pre-dates the photograph by seventeen years, was drawn for a fellow artist and friend, and is inscribed 'To Alfred Rich from

William Orpen, 1910'. This odd little circular self-portrait has a curious quality, not least in the colour scheme: predominantly sickly green, with a map on the wall tinted yellow, and the artist's hair brushed with brown. Orpen obviously laid down the initial basic wash of colour and then worked over this in pencil. In certain areas where he needed stronger highlights he has rubbed so hard that he has removed the surface of the paper. The artist's penetrating stare, with his brow furrowed and mouth tensed, is one of intense concentration. The head is treated with great precision, and the modulation of the skin has been achieved by a series of fine lines. The head is the focal point of the composition and it takes a while for the compass hole left behind in the paper (between jawbone and collar) to register. The body is pitched forwards, adding to the tension and concentration, while the fussy necktie provides a touch of gaiety otherwise absent from the work. From Orpen's face

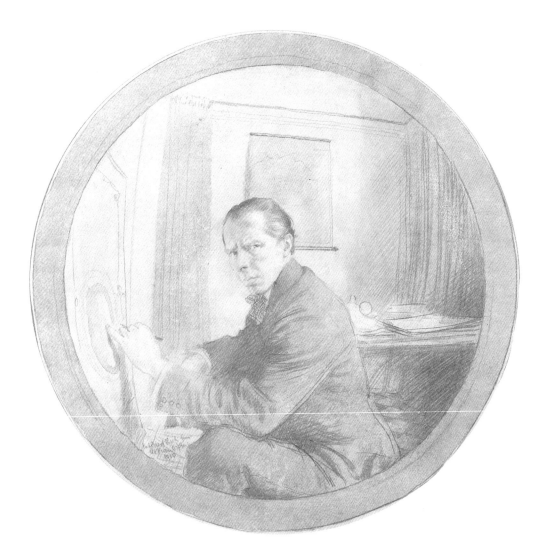

our attention moves to his hand. Poised
with pencil, the little finger keeping it
steady, our eye is then led to the roundel
on which he is working, lightly indicated
on the paper pinned to the drawing
board. We realize that Orpen is at work
on the very same picture that we are now
looking at, which is the image he sees
of himself in a mirror.

Pencil and wash, 1910
Self-portrait
(*NPG 2638*)

Bromide print, 1971
By Bob Collins
(NPG X34132)

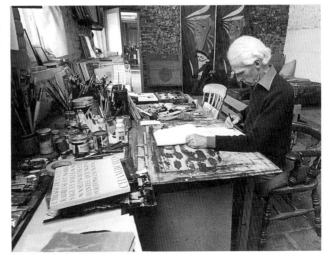

John Piper
(born 1903)
Artist

Peggy Angus's drawing of the artist John Piper portrays her relaxed subject sitting comfortably in a contemporary bentwood rocking chair. The tabby cat draped across his lap, the easy manner in which his chin rests on his hand, and the cosy bedroom slippers all combine to produce a restful, friendly portrait that has a more intimate feel, perhaps, than would an official commission. Angus's obvious delight in patterning, rendered in mixed media, is a strong element, and reflects her work as a leading wallpaper designer. In the background she re-creates Piper's painting *Forms on Dark Blue* (1936, later destroyed) by working coloured crayons into a gouache base, the landscape format of his abstract painting underpinning the rectangular shape of her work. The chevron-patterned floor guides our eyes into the picture space, while the other lines, notably those on Piper's trousers, guide us to the face of the subject.

In contrast to the relaxed, contemplative pose of Angus's portrait, the photographer Bob Collins presents us with a view of the artist in his working environment. By adopting a landscape format Collins offers us a wide view of the studio with its stone floor, solid wooden chairs, wood-burning stove and the large table, crowded with a variety of artist's materials, on which Piper is working. Piper himself, pencil in hand, is oblivious to the photographer as he looks down at his sheet of paper with · rapt concentration. His snowy-white hair and distinguished profile form the focal point of the composition, from which our gaze follows Piper's own down on to the expanse of white paper on which he works and out into the surrounding clutter of his studio.

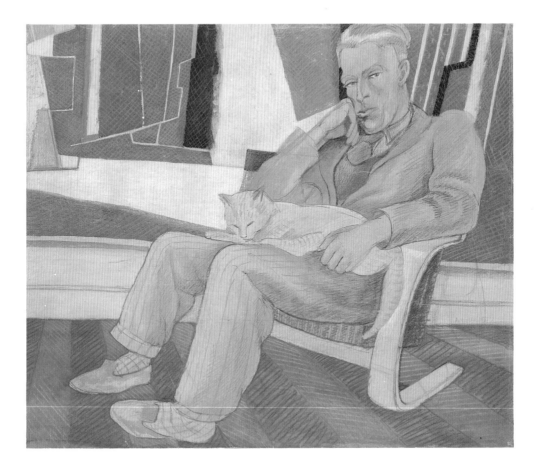

Pencil, watercolour and crayon, 1937
By Peggy Angus
(NPG CP52)

Bromide print, 1988
By Juliet van Otteren
(NPG X32776)

Kathleen Jessie Raine
(born 1908)
Poet, scholar and critic

Victoria Crowe's painting is constructed as a spiral of memory and reflection, allusion and atmosphere. Kathleen Raine is placed close to us in the foreground, in shadow and some-what blank-faced and abstracted, a feeling conveyed not only in her gaze but also in the way that she is painted. Behind her is a flurry of activity as swathes of grey-green, half-painted images connect in pattern and in form. References are numerous – medieval and prehistoric, youth and age – and the various Latin inscriptions incorporated in the work evoke ideas of visibility and invisibility. Raine herself was pleased with the portrait, described by the artist as 'the poet seated in front of her Venetian mirror given to her by painter and close friend Winifred Nicholson. The mirror reflects many visual images of her poetry, reference to a poem called "The moment" and three further references to Kathleen, as a young girl and as a maturing woman.'

Juliet van Otteren's photograph is a rather harshly lit and striking close-up study of the poet. Such lighting can often produce an unflattering result, but here the photographer has manipulated the flat white areas and used these to enhance the quality of the sitter's eyes, which, together with Raine's slight hint of a smile, bear witness to the depth of her humour and understanding.

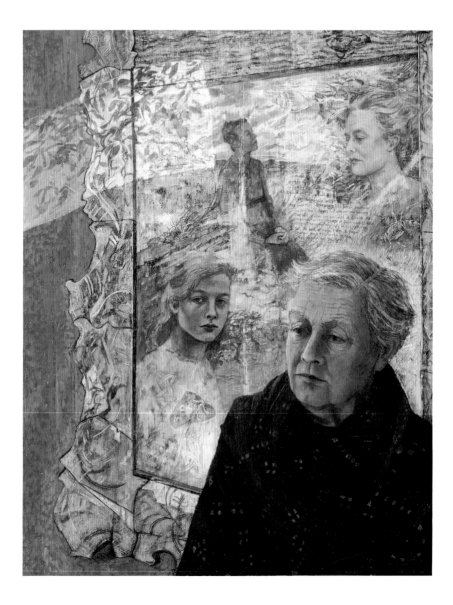

Oil on hardboard, 1984
By Victoria Crowe
(NPG 5748)

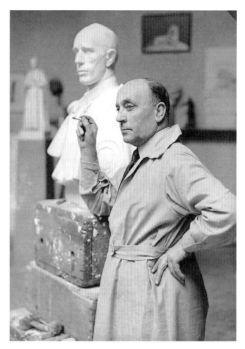

*Modern bromide print
from an original 5″ × 4″
nitrate negative, 1937
By Howard Coster*
(NPG X23992)

Sir William Reid Dick
(1879 – 1961)
Sculptor

Philippe Ledoux's painting of William Reid Dick, who was elected Royal Academician in 1928 and later President of the Royal Society of British Sculptors (1835), is interesting because of its dual perspective. By using a mirror Ledoux shows us views of both the left and right sides of his subject as well as his own reflection as he studies his sitter, who in turn works away at his sculpting. It is a claustrophobic portrait: the curtains shut out the light, the mirror boxes in the sitter, the sculptor overwhelms us with his close, towering presence, and all his sculptures crowd round him, taking up the available space and blocking out the light. There is a pleasant echo between the diagonals made by the working arms and hands and the pool of light which bounces off Reid Dick's bald pate. It is very much a portrait of the obsessive artist – be it Ledoux or Reid Dick – utterly committed, and intent on his work.

Coster took his carefully constructed photograph of Reid Dick in 1937, and it shows a confident and suave figure, a man at the pinnacle of his career. Reid Dick stands before his bust of Lord Halifax, the white marble acting as a foil to the sculptor's darker face and hand and setting up a resonance between the two profiles and different surface textures. The diagonal that links the heads is continued through the line of Reid Dick's arm to his elbow, and is picked up again by the fingers on his left hand. His other arm and hand echo this triangular shape in reverse and introduce a feeling of movement that contrasts with the static quality of the sculpture.

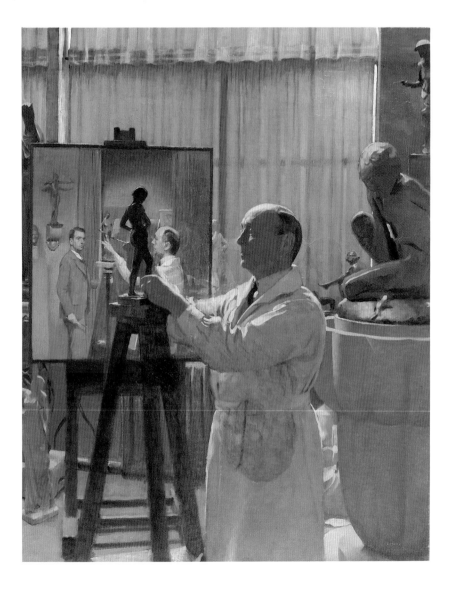

Oil on canvas, 1934
By Philippe Ledoux
(NPG 4809)

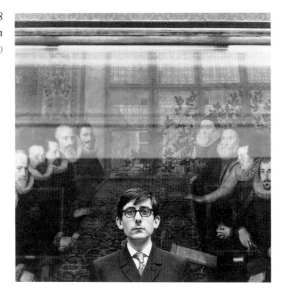

Sir Roy Colin Strong

(born 1935)

**Art historian; Director of the National
Portrait Gallery (1967–1973) and of the
Victoria and Albert Museum (1974–1987)**

At the time when this photograph and painting were created, Roy Strong was Director of the National Portrait Gallery. Best known as an authority on sixteenth-century British portraiture, he was also the first Director to organize exhibitions of photography, beginning in 1968 with the retrospective of Cecil Beaton's work. In this photograph, also from 1968, Beaton pays tribute to Strong by placing him alongside the subjects of his scholarship. The most striking aspect of the photograph is the direct confrontational stare of the sitter, which is reinforced – literally 'backed up' – by the sitters behind him in the painting *The Somerset House Conference* (1604, by an unknown Flemish artist). The painting itself is behind glass, shown by the photographically recorded horizontal reflections which, as we move further into the image, are paralleled by the painted glass window – open, significantly, above Strong's head. Beaton records the top of the frame of the painting by

including a small band of patterned wallpaper, which echoes the pattern of the carpet on the table. Strong is centre stage, his eyes looming from behind his spectacles, framed by these just as the other sitters are confined behind the picture glass. Lit from above, with his white shirt reflecting the light and drawing attention to his brightly patterned tie, he glows like a beacon.

Bryan Organ's portrait also makes use of *The Somerset House Conference* but shifts this work to one side in the composition so that the stark demeanour and outlines of Strong's figure are balanced by the faintly rendered sixteenth-century diplomats and their still duller grey surroundings. Organ's composition makes great play of the horizontals and verticals, adjusting the grey/ochre balance to achieve a flat block pattern on the left which accelerates into the complex carpet rhythms that form

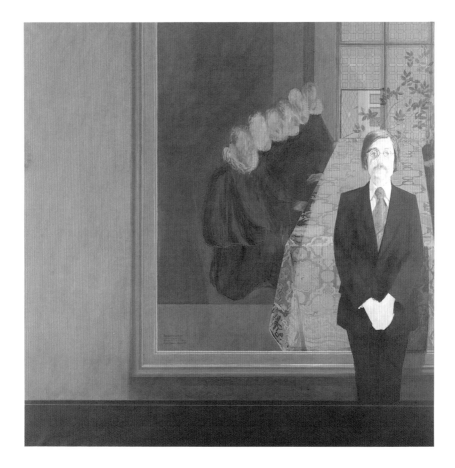

Strong's immediate background. From
the olive branches and the window
leading, the elaborate carpet takes us
through the painting and through the
centuries to Strong's pop-art tie – the
brightest note of colour in the work, and
so evocative of the 1960s, as are his 'John
Lennon' wire-rimmed spectacles.

Oil on canvas, 1971
By Bryan Organ
(*NPG 5289*)

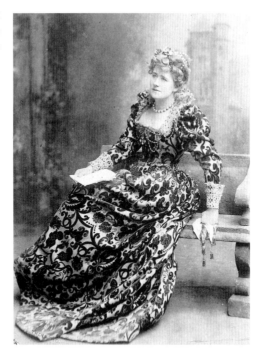

Albumen cabinet print, 1882
By Window and Grove
(NPG X16969)

Dame Alice Ellen Terry
(1847 – 1928)
Actress

This full-length photograph of Ellen Terry, taken in the photographer's studio, shows her dressed as Beatrice in Shakespeare's *Much Ado About Nothing*, a production staged in 1882 at the Lyceum Theatre, London. Terry is seated as if in a garden, with a painted backdrop of a fairytale castle behind her to suggest a scene from the play. Sitting upright, she stares out into the middle distance, a look of thoughtful melancholy in her eyes. In her hand is a letter and her body is supported by her outstretched arm, her knuckles resting on a lacy handkerchief. This is very much a portrait of an actress, able to conjure up another personality at will and to pose as if seized in a pause during the action of the play.

Forbes-Robertson's painting is a sombre, rather low-key portrait of this vivacious and outgoing actress whom he met in 1874, a meeting he described at length:

I was ushered into the drawing room, the decorations of which, for those days, were very novel and bizarre. The curtains were of pale blue Japanese pattern in cretonne. There was a dado of matting, matting covered the floor, and the few chairs that were in the room were of bamboo. In the centre of the room was a full-sized cast of the Venus de Milo, on a pedestal about three feet high on the ledge of which was a censer in which incense was burning, the tapering clouds of which spiralled round the noble form of the statue. Into the back part of this blue and yellow room floated surely a wraith, for the attenuated and beautifully proportioned figure before me was wrapped in a light blue kimono, and thus, with her pale face and yellow hair, free and flowing, she melted into the surroundings. But presently this wraith materialised, and welcomed me with outstretched hands. The ethereal creature looked more like eighteen than twenty-six, and in manner, well – she was just a girl, and indeed this youthful buoyant spirit she maintained all through her life, infecting with it all those who came into contact with her.

This is essentially a romantic, private view of the actress, though her presence

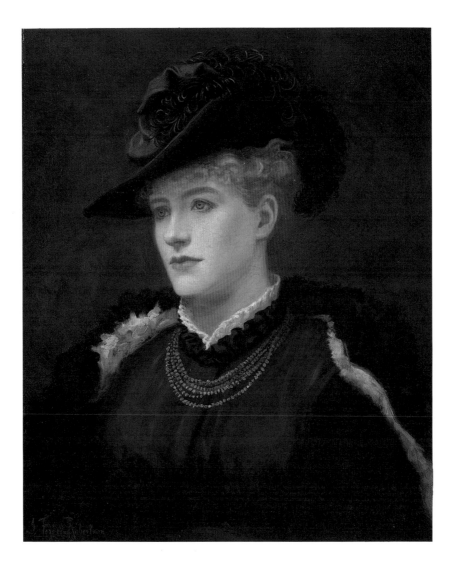

nonetheless is a dramatic one. The artist
has used a dark background to contrast
with the light on Terry's face and the
white ruff surrounding her neck; a dark
feathered hat sets off the mass of blond
curls piled high on her head and her
sensuous red lips animate an otherwise
expressionless, wide-eyed face.

Oil on canvas, 1876
By Sir Johnstone Forbes-Robertson
(NPG 3789)

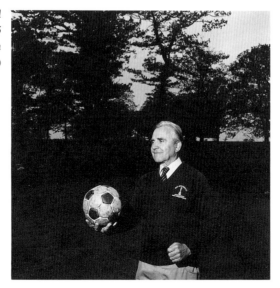

Trade Union Leaders
Joseph Gormley, Baron Gormley of Ashton-in-Makerfield
(born 1917)
Sidney Weighell Thomas Jackson
(born 1922) *(born 1925)*

In this lively working drawing the artist Hans Schwarz has initially used red crayon to denote the mass of each of the figures and how they relate to one another within the composition. His decision-making process is clearly visible: for example, in the heavily worked marks on Weighell's shoulder. Weighell, the central figure, who is easily recognizable even though the portrayal is schematic, has his features enhanced in pencil, emphasizing his square jaw and his chin line. Gormley, holding a hat, stands to the left, roughly sketched in in pencil, and we can just make out Jackson's characteristic handlebar moustache (in the finished painting the positions of Weighell and Jackson are reversed [NPG 5749]). The portrait drawing of Weighell, done from life in September 1984 in compressed charcoal on white paper, is fluent and stylish; his frenetic character is brilliantly captured by the artist's fierce and energetic line.

Due to the busy schedules of the sitters it was necessary to draw each one separately and subsequently to invent a format for the group composition. Trafalgar Square was an apposite choice of venue as it is traditionally here that public demonstrations commence or terminate and speeches are given.

Liam Woon's black-and-white, square photograph of trade union leader Weighell, taken in October 1985, plays with the idea of the negotiator as gamester. An ex-footballer, Weighell is pictured in his Yorkshire back garden holding in his splayed hand a leather ball whose pentangular panels echo the lines traced by his outstretched fingers. His other hand is held in a fist which, together with the ball and head, forms a dynamic triangle. We know that the shot is posed, but we are offered conflicting information by the photographer. By using flash in combination with daylight he has created a somewhat surreal effect

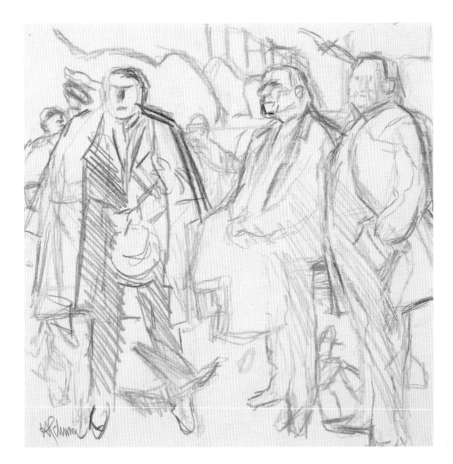

(we are unclear about the time of day),
which is compounded by the suggestion
that the game is being played in a wood.
It is the professional smile that finally
belies the character of this sitter, how-
ever, a hint of self-satisfaction combined
with genuine pleasure at having caught
the ball.

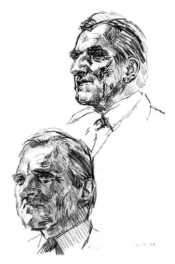

Pastel, crayon and ink, 1984
By Hans Schwarz
(NPG 5793 [2&3])

Bromide print, 1936
(previously wrongly dated 1933)
By Madame Yevonde
(NPG X13174)

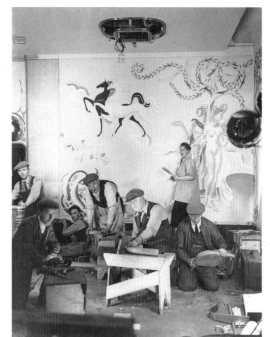

Anna Katrina Zinkeisen
(1901 – 1976)
Artist

Anna Zinkeisen is best remembered for her work as a muralist, but was also known for her stylized portraits. Her self-portrait of *c.* 1940 is an altogether striking work, notable for its controlled brushwork and bold use of red and blue. This technical precision is in keeping with the image of herself that Zinkeisen presents us with: immaculate hair, clean, sculpted nails, shining bracelet at her wrist and perfectly applied lipstick. Particularly clever is Zinkeisen's use of shadow: the brightly lit right-hand side of her face contrasts sharply with the background, thus bringing the outline of her forehead, nose and neck sharply into relief. Her 'contrapposto' pose allows the same light source to pinpoint her elbow and guide our eyes into the work and down towards the action – the brushes and rags grasped at the ready in her hand. Despite her imposing stance her face betrays little expression or emotion.

Madame Yevonde's photograph, taken a few years earlier, is more of a documentary record. It shows the artist at work on murals for the Cunard liner *Queen Mary,* launched in 1936. She has not finished her painting but, interestingly, has already signed it (the signature, like the red lips and kiss curl, were her trademark). In the foreground a group of carpenters, traditionally cloth capped, with white shirts and ties beneath their overalls, are hard at work – a male chorus line to counterpoint the femininity of the artist. Behind them, silhouetted against her mural – a stylized, romantic dream of prancing horses and scantily-clad lovers – stands Zinkeisen clasping her brushes in the same way as in her self-portrait. In its content and composition this photograph clearly illustrates the divide between art and craft, contrasting the physical nature of the craftsman's work with the more cerebral approach of the artist's. It hints, too, at the photographer's feminist sympathies.

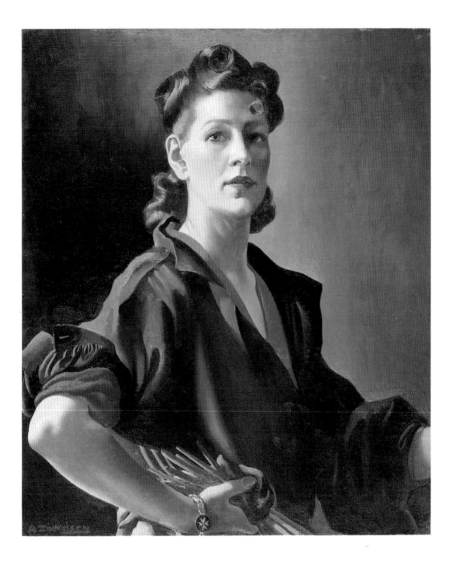

Oil on canvas, c. 1940
Self-portrait
(NPG 5884)

Index of artists,
photographers and sitters

Index of artists, photographers and sitters

continued